D1121951

COLORING

THE

HUMAN

CANVAS

DIANE K. STEVENSON

ARIEL BOOKS

ANDREWS AND MCMEEL

KANSAS CITY

COLORING THE HUMAN CANVAS

TATTOOS

T
A
T
T
O
O
S

Photos courtesy of:
Archive Photos, Robert Butcher,
and UPI/Corbis-Bettmann

Flash courtesy of
New York Body Archive

This book was set in Centaur MT
with display in Xebec.

Book design and typesetting by
JUDITH STAGNITTO ABBATE

ISBN: 0-8362-1523-0
Library of Congress Catalog Card
Number: 96-83368

CONTENTS

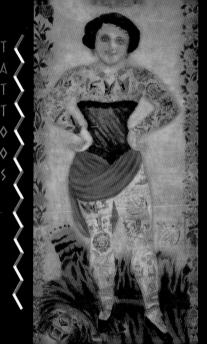

TATTOOS

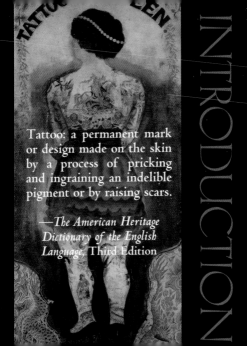

Tattoo: a permanent mark or design made on the skin by a process of pricking and ingraining an indelible pigment or by raising scars.

—*The American Heritage Dictionary of the English Language,* Third Edition

The neolithic "Iceman" had tattoos behind his knees. A four-thousand-year-old Egyptian mummy had a tattoo on her stomach. Anglo-Saxon kings had them. According to myth, Japan's first emperor had them. Eleventh-century crusaders returned from Jerusalem bearing tattoos. In the nineteenth century the Prince of Wales returned

from a journey to the Middle East with one. After the opening of Japan in the 1850s, Prince George and Prince Albert, grandsons of Queen Victoria, were tattooed there, and so was the future Czar Nicholas II of Russia. Kaiser Wilhelm of Germany, Princess Waldemar of Denmark, and King George of Greece all had tattoos. Winston Churchill and his mother, Joseph Stalin, and Franklin Delano Roosevelt had them as well. The present Prince of Wales has a tattoo, as do Barry Goldwater and John F. Kennedy Jr.

It's hard to know where to look these days if you don't want to see someone with a tattoo: college students, movie stars, musicians, artists, women as well as men. Tattoos today are almost as popular as designer jeans once were and name-brand

running shoes still are. The current popularity of tattoos is a fad, and no doubt a passing one. Like most fads, tattoo crazes come and go, and have done so in the West for hundreds, and perhaps thousands, of years.

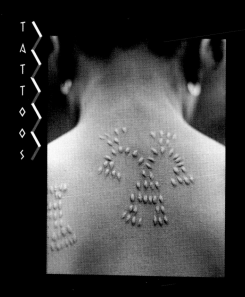

TATTOOS

One story holds that the first tattoos were accidental. A caveman rolled in his sleep onto a pile of smoldering coals that burned into his skin, leaving indelible marks. He liked the result, strove to duplicate it by pricking the skin and inserting liquefied coal ash or soot, and voilà, tattooing was born. Not only were his designs decorative, they were hard-

earned, and the cave man was proud of the pain he had endured.

THE "ICEMAN"

The oldest mummified human being ever found, frozen fifty-three hundred years ago in an Alpine glacier, is also the oldest known tattooed man. Discovered in 1991 in the Italian Alps, the neolithic "Iceman" was fully clothed and carried tools with him—all of which were well preserved. On his back and behind his knees were found several simple tattoos, composed of mere lines.

AMUNET

The oldest known female with a tattoo was a woman from Egypt named Amunet, possibly a priestess of the goddess Hathor. Her mummified body dates from the Eleventh Dynasty, which places her somewhere between 2160 and 1994 B.C. One simple elliptical design, made of dots and dashes, was still intact on her stomach. The priestess also had other miscellaneous marks on

her arms and thighs. At least two other female Egyptian mummies with tattoos, from roughly the same period as Amunet, have been discovered as well.

Before the discovery of the neolithic "Iceman," it was thought that tattooing had originated in ancient Egypt and traveled from there to the Middle East, India, the Far East, and finally to the Pacific islands, where seventeenth-century Europeans eventually discovered the art and brought back "specimens" from their travels. But the tattooed "Iceman," obviously an ancient inhabitant of what is now western Europe, predates the priestess Amunet, indicating the art has even older roots.

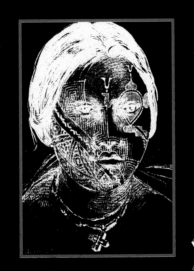

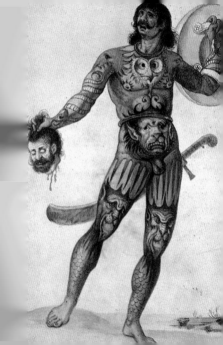

EUROPE AND THE

BRITISH ISLES

What little is known of early tattoos in western Europe comes mainly from written histories rather than from pictorial evidence or artifacts. Around A.D. 200 Roman soldiers returned to Rome with tattoos they had copied from the native Picts and Celts of the British Isles. This

T
A
T
T
O
O
S

provoked quite a craze in Rome, until Emperor Constantine issued a decree against tattooing. Apparently, however, the popularity of tattoos either persisted in spite of the ban or was revived toward the end of the eighth century when a second decree was issued by Pope Adrian I.

During the colonization of North America, the British and the French were intrigued by the tattooed and painted native tribes they encountered. When, in a surge of ancestral pride, the Europeans examined their own pre-Christian Celtic origins, they discovered that those indigenous peoples had also most likely had tattoos. And when they attempted to reinvent Celtic tattoos, having very little tangible evidence, they were influenced by the designs used by the natives

of the New World. So it is that many eighteenth-century illustrations show ancient Celts bearing the tribal motifs of Native Americans.

The last record of indigenous tattooing—that is, native rather than imported—in Europe might well have been from the Battle of Hastings in 1066, which saw the defeat of the Anglo-Saxon King Harold. According to legend, the king's men were unable to locate their fallen leader's mutilated body among the dead and dying, so they summoned King Harold's lover Eadgyth (or his wife Edith, according to one version) to the battlefield. She alone was able to identify the corpse because of her intimate knowledge of the tattoos that covered his body.

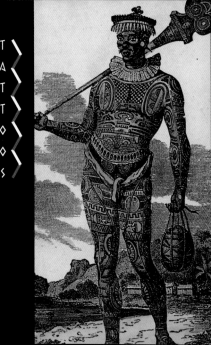

They staine their bodies
by indentinges, or pricking the skin
with smalle instruementes made
of bone, cutte into short teethe;
which indentinges they fille uppe
with dark-blue or blacking mixture
prepared from the smoke of an oily
nutte. . . . This operation, which
is called by the natives *tattaw*, leaves
an indelible marke on the skin.

—*The Journals of Captain Cook*

EXPLORATION OF THE PACIFIC

Modern Western man's first infatuation with tattoos occurred in the seventeenth and eighteenth centuries during the exploration of the Pacific Ocean. European voyagers had discovered America, but they soon realized this was a brand-new continent, not the Eastern land of wealth and exotic spices they were seeking. Determined explorers pressed on until they reached the fabled lands of the Orient.

The first of these explorers to return to Europe with a tattooed native of the South Pacific was an English seaman named William Dampier. In 1691 Dampier brought back a Polynesian known as

the Painted Prince, who became an instant sensation. Dampier's display of him in Britain began the tradition of exhibition that would come to include circuses, dime museums, and carnival sideshows.

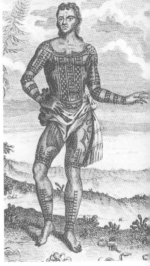

Another English navigator, Captain James Cook, saw his first tattoos when he landed in Tahiti in 1769. Cook and his crew were astonished by these human "canvases" and

resolved to bring back specimens of the decorated natives. Getting a tattoo did not become popular, however, until Cook returned from a second journey in 1775, bringing with him the Great Omai, whose full-body tattooing attracted the curiosity of the upper classes.

Omai in all his painted glory was presented to elite audiences in their fashionable drawing rooms, and according to the biographer James Boswell even Dr. Samuel Johnson, preeminent literary critic of his day, was moved to take in the show. It's unlikely that Dr. Johnson himself got a tattoo (a grueling experience in those days, when all tattooing was done by hand rather than by machine), but apparently several

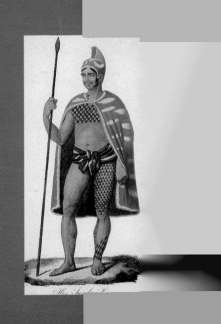

of Omai's wealthy admirers signed up to have their skin decorated.

British aristocrats were off on a tattoo binge. French and British sailors got into the act as well: Their extensive tattoos were as titillating to audiences as those of the Painted Prince and the Great Omai, especially when accompanied by the sailors' lurid stories of captivity or torture at the hands of "savages." Aristocrat and sailor alike traveled to the Pacific and the Orient seeking tattoos, which they then wore proudly as a record or badge of their journey and their bravery. Eventually the tattoo fad petered out among the British upper class, but it continued to be popular with sailors.

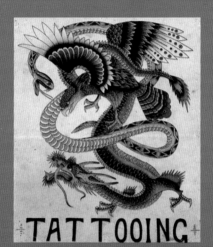

TATTOOING

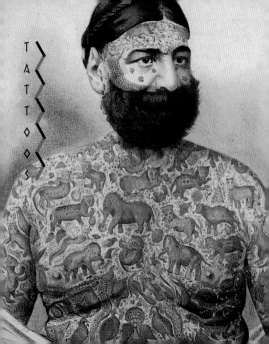

TATTOOS

THE CIRCUS AND THE
SKIN MARKET

PRINCE CONSTANTINE

A circus poster from the 1870s announces "Captain Costentenus: The Greek Albanian Tattooed from Head to Foot in Chinese Tartary, as Punishment for Engaging in Rebellion Against the King." An illus-

tration of this tattooed man—whose real name was Alexandrinos—shows two lions facing each other across his forehead, a snake down each cheek, elephants, peacocks, and birds and animals of every description—real and imagined—over his arms and legs and torso and feet and hands. Even his eyelids and earlobes appear to be etched. By the early 1900s, Barnum and Bailey Circus was paying its tattooed man—now called Prince Constantine—one thousand dollars a week to display the 388 small animals that covered his face and body.

To be tattooed was one thing, to be forcibly tattooed another. The story that Prince Constantine told gawking audiences described not only his capture by "Chinese Tartars" but also the cruel fate of his com-

panions who had died during the ordeal, leaving only Constantine to tell the grisly tale.

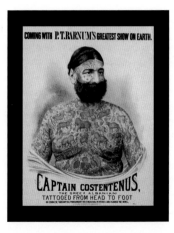

BETTY BROADBENT

Betty Broadbent was born in 1909. At the age of fourteen, she worked as a mother's helper in Atlantic City, New Jersey, and began, during her days off, to wander on the beach and the boardwalk. There she met tattooist Jack Redcloud and became his human canvas. Her tattoos landed her a job with the Ringling Brothers and Barnum and Bailey Circus; she did shows in the 1930s with movie star Tom Mix and rode bucking mules with Harry Carey.

Betty eventually became a tattoo artist herself. Beside the fact that a woman with tattoos was a very unusual spectacle, a reason for Betty's popular appeal was the

contrast between the girl-next-door freshness of her face, which she kept free of tattoos, and the designs over the rest of her body.

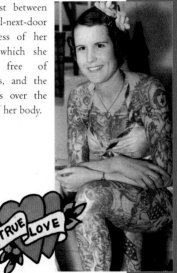

TRUE LOVE

THE SKIN MARKET

When Prince Constantine died in
the 1920s, samples of
his decorated skin
were cut out and pre-
served for posterity.
Samuel M. Steward,
the American tat-
tooist known as Phil
Sparrow, reports that,
until it was stolen
from his Chicago
studio, he was in
possession of one
such memento,
which he des-
cribed as "a brownish,

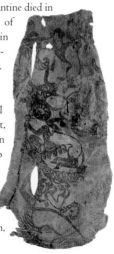

dried, and possibly tanned gruesome little relic." Gruesome indeed.

But gruesomeness was part of the attraction. In the previous century, collecting the preserved heads of tattooed Maori warriors had become so popular in Europe that it sparked unprecedented carnage among the Maori during their tribal wars in New Zealand. In order to meet the growing demand, the Maori went beyond the simple acquisition of war booty, in which the head of a warrior killed in combat was kept as a trophy by the survivor—now they took to forcibly tattooing prisoners, executing and decapitating them, and putting their severed heads on the market.

In 1831 in New Zealand, a ban was imposed on the sale of Maori severed heads,

39

T
A
T
T
O
O
S

and exportation eventually died out. Europeans had to make do with the heads already in their possession. As late as 1902 Major General H. G. Robley arrived at auction rooms in London with "four large portmanteaux" containing thirty-three Maori heads. An extant photograph shows him seated with the heads hanging neatly on hooks behind him.

Legal and public collections of tattoos no longer exist, except in Japan, where even today the art—tattooed skin cut from dead bodies—is saved and displayed like any other. No one in the Japanese collections, however, was killed for art's sake.

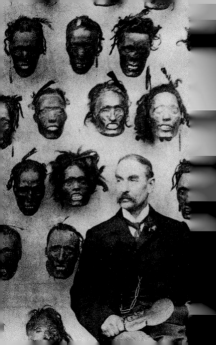

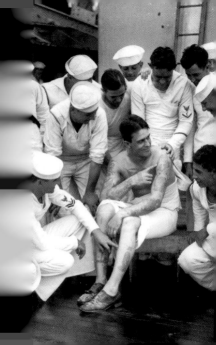

. . . his long skinny arms all covered with anchors and arrows and letters, tattooed in with gunpowder like a sailor-boy's.

—*Tom Brown*, 1857

Sailors kept the art of tattooing alive during periods when its popularity waned among the aristocracy. Sailors developed their own set of

practices and superstitions as colorful as the designs themselves.

For the sailor who had crossed the equator there was a special tattoo called "Line Crossing." The tattoo of a dragon signified the crossing of the International Date Line. Once a sailor had accumulated five thousand sea miles, he was entitled to a bluebird tattooed on one side of his chest. Five thousand more miles entitled him to a second bluebird on the opposite side. Designs from the 1930s offered an American sailor elaborate motifs for linking the two birds across his chest with an array of flowers, butterflies, and banners with the names of loved ones.

Sailors, like other people who engaged in dangerous professions, invested tattoos

with the power to aid and protect. A tattooed cross on a sailor's chest was believed to guarantee him a Christian burial; a crucifix on his back would insure him that he would never receive a flogging, for who would risk the sacrilege of inflicting blows on the figure of Our Lord? A pig or a rooster tattooed on a sailor's heel was thought to act as a charm against drowning—because the pig or rooster, being unable to swim, was expected to head straight for shore. "Hold Fast" written across his knuckles would prevent a

sailor from losing his grip at sea and falling overboard.

Sailors played a vital role in keeping tattoos alive in the West. The tattoos that sailors liked best—anchors, ships, crosses, hearts, and roses—are what we have come to think of as traditional tattoos.

"SAILOR JERRY" COLLINS

World War II—the war in the Pacific—exposed countless Americans to the tattoos

of their own sailor community as well as to those of Eastern cultures. Hawaii, in particular, was a crossroads of these two worlds, East and West. One of the great facilitators of the cross-fertilization that followed the end of the war was "Sailor Jerry" Collins, a tattoo artist based in Honolulu.

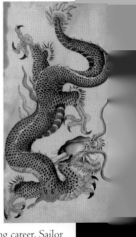

Early in his tattooing career, Sailor Jerry initiated an active exchange of letters with all tattooists he considered

T
A
T
T
O
O
S

as serious as himself in their practice of the craft and their commitment to the art. Besides the exchanges between himself and Hawaii-based Chinese and Filipino tattooists, Collins tirelessly maintained an international network of tattooists who swapped stories, stencil designs, pigments, technical information, and even photographs of their work.

With the single-mindedness of a missionary whose goal was to raise tattooing to the art he knew it could be, Collins sought out contacts all over the world, including the greatest Japanese tattooist of his day, Horiyoshi II. He corresponded with American traditionalists like

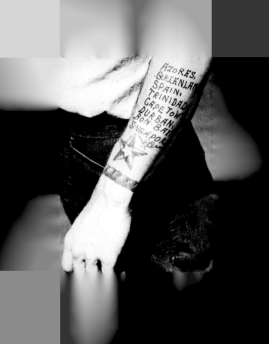

Tatts Thomas, Paul Rogers, and "Brooklyn" Joe Lieber. He had tattoo pen pals in England, Europe, and Hong Kong. He was good friends with the Australian tattooist, Long Andy Libarry, and learned from him such techniques as shading nudes with brown rather than black because black tended to smudge with time and brown didn't.

One story about Sailor Jerry is that his friends wanted to give him the best possible practice opportunity: the chance to tattoo a cadaver. They brought him to a morgue, where, on a cold, clean slab, lay a body covered with a sheet. His friends left the room to act as lookouts; Sailor Jerry pulled out his tools and set to work. When he lifted an arm off the slab, however, the "corpse" let out a blood-curdling scream and

sat bolt upright in front of him. When he recovered from the shock, Sailor Jerry realized he'd been the victim of an elaborate practical joke.

Modern tattoo masters like Donald Edward Hardy know that they owe a great debt to Sailor Jerry, who died in 1973, just at the beginning of the renaissance in tattooing he had anticipated and done so much to bring about.

You shall not make any cuttings in your flesh on account of the dead, or tattoo any marks upon you.

—Leviticus 19:28

Surely our predecessors did not treat tattoos as merely decorative, a matter of fashion and fad. Anthropologists tell us that tattoos serve a number of functions: they denote rank or status, they mark rites

of passage, and they can have magical significance. Images etched on skin to act as charms are almost universal.

Sailors relied on their tattoos to ward off death or danger. A tribal woman from the Hawaiian Islands with a row of dots around her ankles reportedly believed the tattoo would ward off preying sharks; a tribal man in Greenland had a tattoo between his eyes of the shark he harpooned, believing the tattoo would help him remain unrecognized by the shark in a future reincarnation and thus prevent the shark from taking its revenge.

MOKO

Maori facial tattoos are singular. Unlike the other marks Maori men and women had on their bodies, tattoos on their faces were chiseled rather than punctured. For the body, needles were used; for the face, tools resembling those required for carving wood. The pain must have been excruciating. The geometric designs that resulted were called *moko*.

On one early Pacific exploration, an artist who had been commissioned to record the plant, animal, and human life encountered on the trip executed a charcoal portrait of a Maori chief. He worked diligently, getting the details just right, rubbing out a line here and there, until finally the picture was what he wanted: an admirable representation of

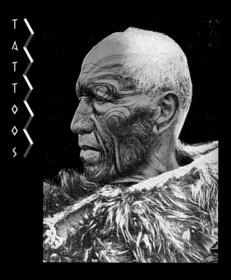

TATTOOS

the real man, tattoos and all. Proud of his work, the artist handed over the portrait.

To his surprise the Maori chief threw the portrait to the ground and set about making his own drawing: he copied one of the *moko* designs from his face. When the chief had finished, he pointed to the artist's portrait and said with disdain, "This is *not* me"; he then turned to the tattoo he had drawn and declared, "This is me." His *moko* tattoo, not his portrait, defined his identity. In fact, at the beginning of the nineteenth century, Maori chiefs who couldn't write signed official letters and documents with their *moko* designs.

TRIBAL WOMEN AND TATTOOS

Among tribal women, tattoos are often a mark of distinction. Generally, the more tattoos a woman has, the higher her status. In some cultures, a woman's tattoos are believed to ensure her admittance to heaven, and the number of tattoos determines just how well she will be treated there.

The young girls of the Mer people of India are tattooed starting at the age of seven in preparation for marriage; their tattoos are proof that they come from a good family and will make good brides.

The Newar of Nepal believe that tattoos bring them good luck in the next life, and that they can even sell them there. The

Dangs of India offer more dire predictions: a woman without a tattoo will not enter heaven at all. One member of this tribe went so far as to assert that "if one is not tattooed and after death goes to God, a red-hot plowshare will be used to make the mark."

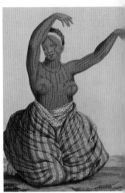

The Maldaris of Gujarat, India, believe that if a woman is not tattooed she will be reborn as a camel. As recently as the 1930s, an Alaskan girl could be told that without a tattoo to protect her, evil spirits would turn her into a dip-guard for a sea-oil lamp when she died.

TATTOOS AND UKIYO-E

Tattooing has much in common with other popular arts. For a striking example of shared ground between tattoos and other kinds of graphic art, compare the Japanese tattooing of the Edo period (1603–1868) with the block prints, or ukiyo-e, being done at that time.

Two renowned practitioners of ukiyo-e, Hokusai and Kuniyoshi, were both doing illustrations for a Chinese novel being translated into Japanese. Its Japanese title was *Suikoden,* and it recounted the adventures of a gang of rebels, similar to the story of Robin Hood. Full-body tattooing was just coming into fashion, and the illustrations for this story enhanced its popularity.

One of the novel's heroes, Shishin, boasted a nine-dragon tattoo. Hokusai's illustrations of Shishin show a fairly modest design, whereas Kuniyoshi's show a full-body tattoo. Hokusai's ukiyo-e album was bound in book form; Kuniyoshi's illustra-

tions were loose-leaf and easily distributed. As a result it was Kuniyoshi's ukiyo-e that were more influential. Characters and even scenes from the story became standards in Japanese tattoo repertoire, much as the "Lady Luck" tattoo, the "Men's Ruin" tattoo, and the "Rock of Ages" tattoo are standards in the traditional American repertoire.

TATTOOS, HIPPIES, AND ROCK 'N' ROLL

Rock stars are a kind of modern-day aristocracy—like movie stars—and all you have to do is switch on MTV to find out how prevalent is their desire to be covered with tattoos. Rock stars, like movie stars, are at once insiders and outsiders. Tattoos lend themselves very well to this double message, for throughout their history they have appealed to the extremes of society: from the drawing room aristocracy to the carnival sideshow audience.

The hippie movement of the 1960s, that outburst of countercultural activity, marks the first strong connection between tattoos and rock 'n' roll music. Janis Joplin and Joan

Baez were two early customers of the tattooist Lyle Tuttle, who is credited with sparking the current interest in tattoos. The popularity of punk rock and the interest it generated in body art and adornment are another big part of today's tattoo craze. Contemporary musicians from heavy metal bands to Hispanic rappers have all gotten into the act. Tattoos are in vogue.

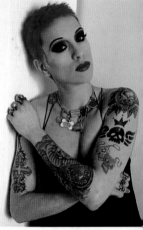

WHAT IS FLASH?

Flash is what you see hanging on the walls of a tattoo shop: all the pictures of all the possible tattoos you have to choose from. "Flash" originally referred to what most nineteenth-century carnival sideshows displayed outside their tents to entice customers inside. Carnivals, circuses, and amusement parks attracted itinerant tattoo artists, and it's no surprise that they adopted the lingo for their own profession.

Flash, like any fashion, changes over the years. What

TRUE ♥ LOVE

one decade considers stylish does not necessarily interest the next. The present-day customer in a tattoo parlor is offered a range of choices; the old standbys are there—anchors, square-rigged sailing vessels, skull and crossbones—along with Betty Boop, hearts, flowers, and "Mom." Added to these traditional favorites are an almost infinite range of new options.

You can choose a Mayan calendar, a samurai in full martial array, a devil with a pointed tail, a bigger-than-life bluebottle fly, a coffee cup spilling over, grapevines, calla lilies, Hindu gods and goddesses, or the label from a bottle of Tabasco—these are all real tattoos found on real people.

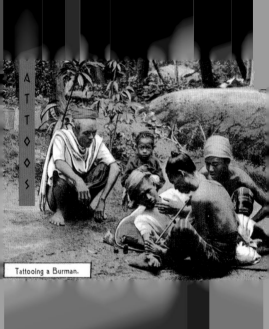

TATTOOS

Tattooing a Burman.

GETTING A TATTOO

As this is a painful operation, especially the Tattowing their Buttocks, it is performed but once in their Life times.

—*The Journals of Captain Cook*

"TO KNOCK OR STRIKE"

Before the Europeans discovered tattooed natives in Tahiti and other parts of the Pacific, the Western word for tattooing was "pricking." From the

T

A

T

T

O

O

S

Tahitian phrase *ta-tu*, Captain Cook fashioned the word *tattaw*, which in turn became the modern English word tattoo. *Ta* in Tahitian means "to knock or strike." In Hawaiian the name for tattooing is *kak au i ka ubi*, "to strike with black," which describes what the first tattooing probably was: a puncture of the skin into which a pigment—soot or India ink, most likely—was introduced. When the puncture wound healed, the pigment remained, a permanent mark.

The instrument used to pierce the skin could be any pointed object, from the bamboo stakes of the old days to today's metal needles. All tattooing used to be done by hand, and it still is in some part of Japan and in Los Angeles among Chicano gangs. A

master of the old method can manage approximately 90 to 120 pricks per minute; a modern master using an electric tattoo machine can achieve between two thousand and three thousand.

THE MACHINE

In 1891 the American tattoo artist Samuel O'Reilly patented an electric tattooing device. O'Reilly took his cue from another American invention, Thomas Edison's electric pencil. And, indeed, O'Reilly's machine looks something like a pencil with an auxiliary battery pack. Although the tattoo machine has gone through changes over the years, the ones used today look much like the one O'Reilly invented and used himself.

Sterilized tattoo needles, held by a needle bar, are inserted into tubes that are, in turn, attached to a tattoo machine. The needles do not hold the ink. There are tiny pockets around each tube—the part that looks like a pencil—that deliver a pulse of ink with each puncture of the skin.

What a brush is to a painter, the tattoo machine is to the tattoo artist. The number of needles and the slant at which the machine is held affect the results on skin much the way that the size and shape of a brush do on canvas: the

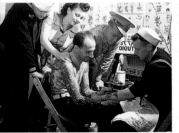

fewer the needles, the thinner the line. Fifty or more needles bunched together can be used to produce shading effects.

THE PROCESS

First the client must choose a design and a color scheme, and decide on the location for his or her new tattoo. Skin right next to bone is much more sensitive to pain than fleshy areas. Next, special transfer paper is used to make a stencil of the chosen tattoo. The skin area is then washed and disinfected, and shaved if necessary. When the stencil is adhered to the skin, it leaves behind a purple design—much like mimeograph paper. Small caps filled with different colored inks are set out ready to go.

T A T T O O S

To help the machine run more smoothly over the skin, the tattooist may apply Vaseline or a similar lubricant. The artist switches on the machine and begins to trace the pattern. Fine-line drawing is done with a single needle; shading and filling with a single color may require as many as fifty needles. Slowly a tattoo begins to take shape. The size of the tattoo, the intricacy of the design, and the number of different colors all affect the length of time needed for completion.

When work is completed for the day, a bandage is applied that should stay in place at least twelve hours. Special ointments are used to ensure that the new tattoo does not dry out. In addition, new tattoos should not be picked or exposed to direct sunlight

or prolonged swimming.

A large tattoo covering the entire back can take months to complete, because of the healing time required between visits to the tattooist. A scar appears, accompanied by minor swelling; with time and proper care, the swelling subsides.

The price of tattoos varies considerably. Well-known tattooists, with national or even international reputations, charge as much as $250 an hour. A small tattoo from a lesser-known artist, however, can run you less than a new piece of clothing or jewelry—and it will last much, much longer.

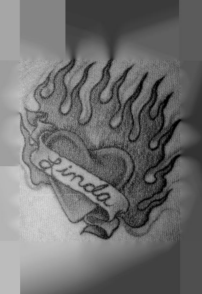

We know that soldiers tattoo their arms and breasts, and impress and trace on them words and figures that neither lotions nor even blisters can efface.

—Malgaigne, 1846

If you were rash enough to have the name of a boyfriend or girlfriend tattooed on your wrist or your thigh, and you've since broken up, you have a

choice to make: (1) live with the fruits of your youthful optimism; (2) have the thing covered over with a darker and more intricate tattoo; or (3) have this living reminder of a failed love affair removed.

In the old days your tattoo would have been cut away or sanded and scoured. Serious scarring was a likely result. Today, the two most common methods of tattoo removal are chemical peels and laser treatments. Neither process is perfect—slight scarring of the skin is still a possibility, and there is a small chance that your skin will retain some coloring.

Chemical peels are best for getting rid of fine-line tattoos (those made with a single needle) and botched cosmetic tattoos. A

chemical process actually removes or "peels away" the pigments.

Laser treatments are the latest and, increasingly, the most widely recommended method of tattoo removal. Lasers introduce bursts of light waves into the skin, breaking down and dispersing the pigments so that they can be absorbed by the body. Though dispersed, the ink is not completely eliminated from the body.

TATTOO REVIVAL

Tattooing has recently made a comeback among young people in Europe and America. The culture of videos and contemporary rock music has been accompanied by a trend toward wild clothing and ornamentation, creating the perfect atmosphere for a revival of the art of tattooing. The power of tattoos to fascinate and intrigue may fluctuate from era to era and culture to culture, but apparently it will never entirely disappear.

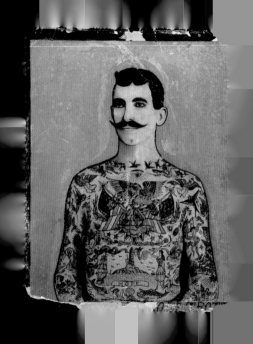